I LIKE YOUR WORK:
ART AND ETIQUETTE

CONTRIBUTIONS FROM:
JAMES BAE
JAY BATLLE
ANDREW BERARDINI
DIKE BLAIR
MATTHEW BRANNON
SARI CAREL
NAOMI FRY
MARIA ELENA GONZÁLEZ
MICHELLE GRABNER
ETHAN GREENBAUM
SARA GREENBERGER RAFFERTY
A.S. HAMRAH
STEFFANI JEMISON
PADDY JOHNSON
ANGIE KEEFER
PREM KRISHNAMURTHY
DAVID LEVINE
PAM LINS
JASON MURISON
DAN NADEL
BOB NICKAS
WENDY OLSOFF
DUSHKO PETROVICH
KASPAR PINCIS
RICHARD RYAN
JESSICA SLAVEN
RYAN STEADMAN
AMANDA TRAGER
RACHEL UFFNER
ROGER WHITE

EDITED BY
PAPER MONUMENT

WENDY OLSOFF

What are the rules of etiquette for the art world?

The rules of etiquette in the art world are unwritten and complex, and whatever rules there are are often broken—brazenly or discreetly, on purpose and by accident. A gallery assistant or intern should not speak unless spoken to. Dealers should not harangue visiting press—but hand them a "press package" and politely ask them if they need more information. Collectors should not tell other dealers or artists what they bought elsewhere. Artists should never approach a dealer at a social occasion about their work. Dealers should stand up and greet a collector when they walk into the gallery or a booth at an art fair—but do not hover. Don't talk to a dealer when they are clearly in conversation with an "important" client or curator. Do not let the public walk out with a price list. The list goes on and on. A certain amount of outrageousness is always tolerated and rules are always broken. Some dealers are known to scream and harass staff when their rules of etiquette are breached. Collectors lowball dealers (and some do not pay), dealers exaggerate their successes, people get drunk, rumors are spread (about bad behavior, often) and the art world goes on... I guess if an art icon is famous for urinating in a fireplace how can there be any rules?

Was etiquette foregrounded in any memorable situation?

Usually it is arrogance or bad training. Lack of experience and social skills.

What customs or mannerisms are particular to the art world?

The customs or mannerisms of the art world are not taught at home (unless your parents are dealers or collectors) or in school. It has to be learned on the job and it can take years. The auction houses, museums, the galleries, the artists, the curators all have their unwritten rules and they all intersect.

When does breach of etiquette play a role in embarrassing or awkward encounters?

One kiss, two kisses, or three? One is never sure.

How should people behave? What would be a maxim for conduct?

That is a loaded question, and I have had a maxim for my own conduct since high school. I try to be nice to everyone every day. I often fail. I also try to listen to the person talking to me at openings. I hate when you are talking to someone and their eyes are darting around checking out the crowd. Some people have reputations for this, and they don't even know who they are. Once, a curator actually grasped my hand, trapping me, while she scanned the crowd.

Has there been a shift in etiquette as the financial climate has changed?

Ahh, everyone gets nicer when there is less money around.

What constitutes bad manners?

At an art fair, the dealers should always introduce themselves to their neighboring booths, and not just say hello when they need to borrow your ladder!

What are the rules of etiquette for the art world?

1 If you're a skinny artist, be clean and neat. If you're a fat artist, be crazy looking and disheveled. Not sure why, but this seems to work best.

2 Negative comments about the artist's work at their opening is the equivalent of taking a shit on someone's birthday cake at their fortieth birthday party. The proper thing to do is to save your negative comments as an anonymous blog post!

3 Don't wear khaki pants.

Was etiquette foregrounded in any memorable situation?

One code of unwritten "etiquette" delivered to me in hushed tones by almost every art-world type immediately upon my arrival in New York was, "Don't EVER walk into a gallery with your slides (this was before jpegs); you'll never get a show that way."

Right after completing my MFA, I walked into one of my favorite galleries, Feature Inc., slides in hand. In return, I got mixed reviews and a job offer. Shortly thereafter, I fell for one of the Feature artists, married her, and we had a baby together.

All the predictions were correct! I never did get a show at Feature Inc., only a job, a wife, and a baby, because I brought my slides into a gallery.

What customs or mannerisms are particular to the art world?

Probably just the tendency to thoroughly investigate any particular group's culture or customs.

When does breach of etiquette play a role in embarrassing or awkward encounters?

I have a friend who, every time I see him socially, cannot coordinate his "kiss" greeting with mine. Sometimes it's two air kisses, sometimes one air kiss, sometimes one real kiss on the cheek, sometimes with handshake and/or pat on the back. It's very confusing and we can never manage to both utilize the same technique.

How should people behave? What would be a maxim for appropriate conduct?

People SHOULD behave nicely… I SHOULD behave nicely… uh…

Has there been a shift in etiquette as the financial climate has changed?

Really there's just more desperation than before (you are going to publish this aren't you? I really need some press right now…)

What constitutes bad manners?

One enigma of the art world is that it is frowned upon to go to an opening solely for the free booze, but it is also frowned upon to NOT serve booze at your art opening—quite the conundrum.

The rules of etiquette provide shock absorbers and grease for the wheels of social interaction. Manners are closely related to etiquette, but are less rule-driven, more creative and spontaneous, and require sensitivity and empathy. I would hazard that etiquette can simply be learned, but manners are a combination of learning and instinct. For that and other reasons, I choose to address both etiquette and manners here, instead of etiquette alone.

Below are two fairly quotidian examples of my youthful lapses in both etiquette and manners, which happened in an art-world context. Both are specific to cross-generational interactions (misunderstandings are more likely between people of different cultures and ages) and both are New York City-centric (things often work differently elsewhere). I'd also note that these conventions are bourgeois. Given that the art world has cherished bohemianism for a while, rules of etiquette can get complicated. If an artist eschews etiquette, that's sometimes perceived as a sign of creativity or even genius. I think European artists are better at this gambit, perhaps because it also implies a kind of staged class warfare, whereas the American art world generally adheres to more middle class mores.

In the winter of 1975 I was an eager young art student visiting New York City from Colorado over the holidays. Several years earlier, when I'd lived here for a year, I'd taken a contemporary art history course at the New School, taught by the critic Jeanne Siegel. Jeanne took us on a couple of studio visits, and one of them was to Rosemarie Castoro's. I was smitten by Castoro's work—free-floating gesso brush strokes mounted on Masonite and installed on the wall. I was also taken with the artist herself: sexy, petite, and dressed entirely in black to match her jet-black hair, and by her funky Duane Street loft with its white-painted floors.

Perhaps because we had a mutual acquaintance, and because I'd been in her loft before, I somehow imagined it was permissible to call Rosemarie at 8:30 am on a Sunday morning to introduce myself, tell her of our history and mutual acquaintance, and ask if it was OK for me to pop up, as I was in the neighborhood and would love to see what she had cooking in the studio. (I'm blushing.) About the only breach of etiquette I didn't commit was to simply drop by and ring her doorbell—someone must have told me that wasn't "done" in New York City. Whether she was flummoxed by my audacity or the fact that I'd woken her, or both, she asked that I call her back in an hour after she'd had some coffee. When I called back (probably exactly 60 minutes later), she invited me up, gave me coffee, showed me a series of sculptures she was working on, and somehow got me out the door without allowing me to realize the inappropriateness and obnoxiousness of my behavior. As I write this I remember another embarrassing detail: I'd taken her a gift, a piece of my own art that was influenced by her work. I won't embarrass myself further by describing that pathetic artwork, but, yes, I imagined I was "seeding" the New York art world.

These are less naive times, but just in case a young artist is reading this without grasping the lessons, they are several. Never call a New Yorker (artist or not) before 11 am on a Sunday morning unless you're well acquainted with that person and their habits. (I realize that today's communication technology changes all that, but you get the point.) Curiosity about an artist's work does not entitle you to enter the sanctity of that artist's studio, and your being interested in an artist doesn't mean they would have any interest in you or your work. (Note that I'm referring to a hierarchical situation—networking between peers is vital and essential.) And never assume that someone will appreciate your artwork freebie; gifts of art need to be extremely well considered, because there is something almost sacred about the art of gifting art.

Not many artists would have had Rosemarie's superb manners in a similar situation. I don't have her class, but I do try to keep her example in mind when a student or young artist, with no encouragement from me, suggests the kind of intimacy I forced on Rosemarie.

About 8 years later, when I was no longer a student and thought of myself as an artist, on several occasions I'd met John Torreano, an established painter roughly 10 years my senior. After what was perhaps our third introduction, in which he showed no memory of the previous ones, I remarked, "Even though you may not realize it, this is the fourth time we've been introduced," or something to that effect.

I perceived John's forgetfulness as a slight: I was not important enough to be remembered. Now that was probably exactly the case, but for behavior to be genuinely rude, it needs to be intentional. Perhaps I'm stating the obvious when I say we are a social species and we're hardwired to climb the social tree; we are by design more likely to remember encounters with those perched on the branches above us than those hanging on the branches below. Evolutionary psychology aside, the longer you live, especially in New York City, the more the introductions, the bodies, and the faces pile up. You are likeliest to remember the people you met early on, and of your own generation. (And note that alcohol often accompanies art world gatherings.) So John's forgetfulness was just that, and not a breach of etiquette or manners. My response, on the other hand, was extremely ill-mannered because it was intended to create guilty discomfort, simply out of hurt pride.

I forget how John responded to my rudeness, but we're friendly today. These days my social position and brain are something like John's would have been then (actually, I'm older and my memory worse) and—excepting very close friends—I reintroduce myself to people, even those of long acquaintance, if I haven't seen them in a while. I'm very appreciative when others do the same as I'm capable of forgetting the names of people I'm actually happy to see. And I know I'm not alone in that.

The examples above are rudimentary. They are very simple compared to the kinds of etiquette and manners that engender the reciprocal altruism necessary to nurture beneficial professional relationships with one's peers. These more delicate behaviors are difficult to write nonfiction "advice" about; one is better off reading literature for clues. I'll say that having good manners is preferable to knowing the rules of etiquette. The former can lead to some harmony and happiness, the latter sometimes leads one to monitor other people's behavior. Of course, knowing both the rules, and when and how to use them, is always the best.

In my early thirties, soon after moving to New York, I began going to a lot of after-opening dinners, where, as a person of no special status, I would end up sitting next to random collectors, editors, and spouses. From a girlfriend who had read *Eleanor Roosevelt's Book of Common Sense Etiquette,* I learned a coping strategy that sometimes proved weirdly effective: when conversation flags, introduce new topics in alphabetical order. I made it a little harder by allowing only artists' names, and a little easier by allowing fibs. So for instance, I would look for a Formica surface, and pretend that I had just seen a great Richard Artschwager sculpture that looked just like it. Arman was another good opener. Had they seen the big Baselitz retrospective, or did they have a weakness for Basquiat knockoffs? For "C," I often brought up Dave Hickey's idea that "Clemente" should be a perfume. Who would wear it? Maybe... Arthur Danto? Carroll Dunham? I often blanked on "E," a difficult letter. Olafur Eliasson? Eakins? Sometimes I would cheat, skipping ahead to easier "F"s like Flavin, Fischl, or Freud. Fischl's being married to April Gornik made for a temptingly easy segue, but she was often a dead end. Better to try Gober, and thence to safe "H"s like Hockney, about whom everyone has opinions. "I" was another tricky letter—Indiana, Immendorff, not a whole lot of depth there. "J," with Judd and Johns, was safe territory again, and "K" even better, with Katz, Koons, and Kienholz, for whom I happen to have a big fondness. Of course, some letters are not just hard, but impossible: no "X" artist at all, at least before the Rise of China. Anyway, it didn't matter because Jim Nutt was the furthest I remember getting.

ANONYMOUS

My experience has been that customs are local, so I can only talk about New York etiquette. Generally, it's important to respect people, their time, and their privacy. Discretion is important. You need to be quiet about half-done deals. Social introductions are important. You can't just send somebody images or call somebody up for a studio visit, etc., if you haven't been introduced over email or in person. It's important to create the illusion that it's not a business and that your relationships do not exist to serve your career.

Studio visits imply no commitment. There can be up to three visits between a gallery and artist with no action, but there can't be four.

What customs or mannerisms are particular to the art world?

It's considered vulgar to acknowledge the business aspect of interpersonal relationships and discussion of the "bottom line." This area of silence can make socializing incredibly confusing, and I think it might explain why New York art gatherings tend to be so guarded. And people do exploit the gray area. For example, a gallerist fires an artist and it's "nothing personal, this is a business decision," but the artist leaves the gallerist, and the gallerist thinks, "how could you do this to me, I thought we were friends?" (Naturally that's the artist's take on things). The aversion reminds me of other seeming paradoxes in American values (like sex obsession/Puritanism) since commerce is such a powerful force in American art.

When does breach of etiquette lead to embarrassing or awkward encounters?

I met with a couple of different galleries in Berlin a few years back. Of course, I'm going by New York rules so in my mind are a.) discretion regarding incomplete transactions and b.) no strings attached to familiarization meetings. The second gallerist I met with confronted me towards the end of our meeting with her knowledge of my "betrayal." You see, she had dinner with the first gallerist the night before, and he almost fell out of his chair when he discovered she was planning to meet with me. I couldn't really understand what she was talking about. Then she explained to me the correct way for artists to behave by relating an anecdote about a German artist who had gone to New York with the express purpose of meeting with galleries and how he had clearly broadcast his intent to all parties. I left Berlin confused and a little offended. I tried to inspire sympathy in my German friends for having been subjected to such strange behavior, but they all gave me confused and somewhat dirty looks.

How should people behave? What would be a maxim for conduct?

Respect people and be considerate.

What constitutes bad manners?

Gossiping is bad manners. Talking trash about people you work with is the worst.

Studio visits are part of the practice of most artists. They enable the viewer to get a behind-the-scenes look at what artists do on a day-to-day basis. A positive studio experience generates a uniquely intimate dialogue. If it goes well, you might offer the artist a show, buy a piece, or, most significantly, provide critical feedback. Studio visits range in spectrum from casual to super formal. Either way, sharing his or her sanctuary is always a very personal experience for an artist, no matter how impersonal the setting—even if the place is swarming with assistants. A studio visit exposes the direct link between the artist and his work. You might learn about the process behind the artist's work, or be made aware of artifacts that inspired him. Either way, it works to your advantage to be generous in this manner with your time. It is a sign of good faith towards the artist, whether you are a curator, collector, dealer, or fellow artist. As a visitor, adhering to some basic rules of etiquette can go a long way in making this exciting and intimate experience go as smoothly as possible for both you and the artist.

1 Try to be on time. If you are going to be late, please notify the artist. In this heyday of modern communication a quick text message will suffice. Many artists find it hard to work before a studio visit. Giving them an exact time frame will allow them to kill time with mundane tasks while awaiting your arrival.

2 Don't cancel at the last minute. Under any circumstances, this is a really annoying thing to do. For an artist, it can screw up their whole day. Bear in mind that it takes time and effort— both physical and emotional—to prepare for a visit, especially if it is high profile. Especially if the artist has offered to cook you lunch as part of the studio visit, canceling 10 minutes before the meeting is very tacky.

3 Take your time, if you can. It helps to start with phatic communication, or small talk about the weather, the space, etc. Don't just rush into talking about artworks. Telling the artist you are in a rush only puts both of you on edge. Nothing constructive can be achieved in this manner.

4 Don't make the artist feel guilty for taking up your time by coming to see their work. Why did you set up a studio visit in the first place? This is just power tripping, and that really does neither party any good. You can always ask the artist to send a few images to get an idea of what he or she is up to ahead of time. A Google image search can be revealing as well, and most studio artists have websites.

5 Don't proselytize your opinions about the work, and don't bombard the artist with programmatic criticism. A few samples: "These would be great if you could make them into paintings." "Have you ever tried making these bigger?" "I'm really curious to see what you'd do if you had a smaller studio." "Do these really have to be framed?" "Why would I sell these works for $5,000, when I could sell a Miró for $5 million?" "I'm really interested to see what you do next."

5.5 This said, the artist also knows that you are going out on a limb by putting yourself in such an intimate and intense space, and thus won't take your comments too personally (or at least pretend not too). Any criticism is and should be viewed as useful information.

6 It is not a treasure hunt. Let the artist take you through the artwork and let them show you what they want. Some artists do not want you to see unfinished work (and should therefore not have anything in sight that they don't want you to comment on).

7 Don't ask how much something costs unless you're interested in buying the work. Some artists prefer to leave this to their dealers (if they have a dealer), so only talk about the work itself and not as a commodity, unless it seems right.

8 Some artists sell work directly out of their studio and are much more savvy and relaxed with the financial side of art, so you can even get a deal by dealing directly with them. You might even get first dibs at work that others haven't yet seen.

9 If at all possible, give some sort of feedback to the artist about where this studio visit will lead to, or won't. Don't leave artists on the hook because it is convenient for you. Dealers like to do this, to keep a "wait and see" stance. While this is fine, it can be frustrating to artists.

10 Don't make promises you can't keep. If you are trying to impress the artist, make something happen that you can make happen. This is enough, and artists don't expect too much from the art world.

11 Finally, on a pedantic note, my father-in-law, who once interviewed Andy Warhol at the Factory for *Interview* magazine (Warhol only talked about his brand new watch), recommends keeping a keen expression on your interlocutor's brow. Hands before you makes for good body language, and try to look at as many works as possible, not focusing too much on one in particular. He also suggests that the artist offer the use of the urinal faculties before the work is presented, and a beverage or snack doesn't hurt either.

Standing outside a gallery recently, I was introduced to a stranger, who immediately asked, "What are you in the art world?" An unfortunate starter, I thought, but to the point. I had once imagined a comprehensive book of etiquette that would include precise instructions for navigating every conceivable social situation with absolute confidence, and the part of me that likes to talk to strangers wished I had it with me then, perhaps on a mobile device. My new acquaintance seemed to have no sense of what a complicated question he was asking. I was all too aware, since I had been attempting to write an essay on both etiquette and the art world, finding scant point of entry for either. Neither are easy to define, nor are they comfortable topics.

My imagined book of etiquette was to be a shy person's all-in-one forevermore preventive for the cheek-burning pang of the awkward encounter, far beyond Emily Post's or Ms. Manners's most excessive fantasies. The concept never made it to production, however, since the truly comprehensive accounting of etiquette I had in mind would have been as ambitious in scope and as impossible to execute as the map Borges describes in *Of Exactitude in Science*—one so detailed that it grows in magnitude to physically encompass what is mapped, rendering the description not only useless but absurd. The range of conceivable situations and variables encountered in contemporary social life is simply too vast and too complex to chart accurately. But more to the point, such an index would violate the logic of etiquette as a system of social differentiation.

Etiquette, or politesse, is a set of forms and proscriptions for social behavior, evolved to sustain status quo in social groups. The explicit rules of etiquette, derived from medieval treatises on the management of bodily functions, and refined through mid–20th century newspaper columns on the dinner table and the business meeting, concern minute details for handling obscure contingencies. For example, *When it is necessary to remove something from your mouth, use the same method as you did to insert it.* Useful for finessing an olive pit, but what of a proverbial foot? Implicit rules would apply. And, whereas an explicit code can be mapped, an implicit code, by definition, cannot be. Nor can it be subjected to a transparent process of revision and ratification. As a medium for attainment, maintenance and expression of social status, a system of etiquette is only efficacious to the extent that it remains implicit, and therefore untenable, to the uninitiated. To exhaustively describe the implicit rules of etiquette, were such rules immutable, were such a description feasible, would be to disable the social system of which those rules are an expression by making definite, legible, even teachable, that which is otherwise learned through rites of initiation and enacted through vagaries of suggestion.

"Politesse," like "etiquette," migrated intact to English from

French. Sartre uses the term in an essay on the life and work of Stéphane Mallarmé to describe the poet's revolt against the world: *Il ne fera pas sauter le monde: il le mettra entre parenthèses. Il choisit le terrorisme de la politesse; avec les choses, avec les hommes, avec lui-même, il conserve toujours une imperceptible distance.* (He does not blow up the world: he puts it in parentheses. He chose the terrorism of politesse; with things, with men, with himself, he always maintains an imperceptible distance.) Parenthesize one's object. Set it apart as an afterthought. De-center it. For the artist wielding "a sort of charming and destructive irony," ostensibly polite reserve belies violence "so complete and so desperate that it turns the idea of violence into calm." This is a social judo model of terrorism.

The discreet and mild-mannered artist-saboteur Sartre describes contrasts sharply with a more recent and familiar trope: the misbehaving iconoclasts of Dada, the Situationist International, Fluxus, and punk. Exemplars of these later movements, which emerged within a technological landscape of state-sponsored violence that was unknown to Mallarmé, openly adopted positions of political dissent. Today, a backdrop of violence remains, but radical movements among artists of the professional ilk, if they exist now, lack the traction of preceding models. Instead, the art world is populated primarily by arts professionals and professional artists who pursue careers facilitated through bureaucratic institutions. Consequently, it is the art world that is today paren-thesized by politesse, evinced in part by the institutional jargon of grant applications and museum didactics. Meanwhile, the term "polite terrorism," with the superficial calm it connotes, more aptly describes justice department memos than poetry.

A bureaucracy is defined by a self-replicating structure of explicit regulations—a comprehensive body of rules that, in fact, nobody rules. As such, bureaucratic order is highly prone to degeneration, which results in structural despotism or oppression by the rule(s) of nobody, which is also to say by the consent of everybody. As Hannah Arendt writes in a parenthetical statement in her 1969 study *On Violence*, "If, in accord with traditional political thought, we identify tyranny as government that is not held to give account of itself, rule by Nobody is clearly the most tyrannical of all, since there is no one left who could even be asked to answer for what is being done…" In a functional bureaucracy, professionalism—the subspecies of etiquette native to bureaucratic order—amounts to a beneficent social craft improvised through mass collaboration, a set of behavioral standards that, ideally, smoothes the erraticism of interpersonal relations so that people can cooperate to achieve common goals efficiently. Indications that one is subject and therefore party to the structural despotism characterizing professionalism run amok include a pervasive sense of servitude to anonymously established requirements for success (which one has little or no independent interest in fulfilling, except to satisfy the ulterior compulsion

of career building, dissociated from those aspects of work unrelated to acquisition of social or pecuniary advantage), and the transformation of ostensibly neutral terms ("the art world," "academia") into pejorative expressions of frustration with oppressive circumstances one feels powerless to affect.

Typically, one would submit to standards of professionalism for the presumed rewards of economic and social securities. For artists, the incentive is less direct, since the vast majority of artists is not actually employed as such and instead operates within a market system structured by instability and attrition. Yet, despite the relative dearth of professional benefits, the social pressure to conform to a narrow range of acceptable modes of self-presentation is significant among artists, perhaps due to the fact that the distinction between their personal and would-be professional spheres is obscure. This ambiguity is reflected in the art world on the whole. Nominally, at least, participation in the art world is not merely a matter of being part of some business, industry, or community, but of the very world itself. Nominally, then, the stakes for exclusion are high: to acknowledge directly that one is attempting to limn, or worse, to follow, the rules of the game of belonging would be to acknowledge that one doesn't belong, which would be tantamount to forfeiture.

Increasingly acute social pressure to surreptitiously manage perceptions of one's self and one's relationships for presumed advantage indicates that the mastery of rules has begun to overtake the field of play itself, along with any real agency of the players. Consider the court of Versailles, with its hyper-mannered, politically impotent aristocrats. Like court etiquette, standards of professionalism subdue the fray of heterogeneous purposes, albeit in the service of business, rather than of sovereign. And this is where the matter of professionalism becomes particularly interesting vis-à-vis the art world: if the province of art is unmanageable subjects broached through a kind of play that must be at least temporarily purposeless, or within a field that must contain multiple, diverse and contradictory purposes and questions simultaneously, then a degree of suppleness and uncertainty about the status of the field and of its constituents (and their ambitions) is essential, not problematic.

Can there really be any such thing as a professional artist, then, if the purpose of adopting professional standards is to create social and institutional stasis for the efficient achievement of common (commercial) goals? Is it the authority of artists, pace Sartre's Mallarmé or the provocateurs of the avant-garde, to conduct the play of association—digression from and transgression of dominant social codes? If so, is this authority proscribed by the tyrannical directives of professional standards— on the one hand, the explicit rules of the professional credentialing process, the statement of purpose, the grant application, the marketing blurb, the CV; on the other hand, the implicit rules of the system of nepotism by which official decisions about what

constitutes art are otherwise made? The questions are political.
If the inverse relationship between mannered dissemblance
and political agency persists when the normative constraints
of professionalism become sovereign, then to frame the matter
of art-world etiquette—to consider the importance of codes
of professional etiquette for how and what constitutes artists'
work—is to address the double bind between professionalism
and political autonomy. What are you in the art world? The answer,
and the art world, matter less each time the question is asked.

What are the rules of etiquette for the art world?

it is really hard to do this without sounding cynical—there are so many art worlds out there that it is hard to reflect on rules that apply to all—every event or party or opening or lecture presents a different art world. my art world is very different from anyone else's. it seems i've made a list leaning towards the more difficult/negative moments—but the truth is the shifting panorama of art worlds i spend time in is full of interesting, generous, enthusiastic people who cut through all that cynicism by dedicating themselves to the pursuit of novel experience, liberating ideas, and dynamic conversations. that said, i still spend plenty of time feeling awkward.

1 try not to look over the shoulder of the person you are talking to but no big deal if you can't help it—it's perfectly natural to be more interested in the other people in the room than who you are actually engaging—after all, there are so many more potential beneficial/interesting engagements out there than the one you're involved in. really, i think it's something everyone struggles with. really. and also a room full of people is distracting.

2 don't let on that you want something from someone— this makes the person who is wanted from uncomfortable— better to let them suggest it.

3 these last two sound too cynical—sometimes you have to ask for things.

4 keep it cool—try not to get excited—it makes people uncomfortable.

5 introduce yourself and those around you.

6 try to remember people's names—someone told me that a good way to remember if you can't is to ask them for their email as it usually contains their name.

7 wait until you are at least six blocks away from a show before expressing a negative opinion about the show—this is known as the "six block rule."

8 and many more

9 and don't go to the opening of the nada fair in miami in 2007 and, as a couple, approach an artist who has a large group of works up and tell her/him that you "don't think this is your best work," especially if you physically corner them—literally against a wall. and especially don't do this at the opening which, in case you didn't know, is often already an emotionally turbulent moment combining extreme feelings of exhaustion, self-doubt, confidence, and elation.

Was etiquette foregrounded in any memorable situation?

yes, many—it seems like bad behavior usually foregrounds etiquette.

What customs or mannerisms are particular to the art world?

one of the best things about the art world is the whole gamut of customs surrounding studio visits—it is a fantastic and vitally necessary thing that artists, writers, curators, etc. exchange studio visits, share ideas, engage in conversation.

When does breach of etiquette play a role in embarrassing or awkward encounters?

see number 9 in the first answer and:

i was at the afterparty for a friend's show. there were 10ft long sandwiches to snack on. i was getting myself a piece of sandwich and a well-known photographer approached the sandwich. i guess he thought i was serving the sandwich pieces and he said "i'll have a slice of the turkey"—i was aghast but decided it was easier to get him a slice. it was at a dive bar with pool tables.

How should people behave? What would be a maxim for appropriate conduct?

this list answers both questions:

1 nobody is perfect so we should try to accept everyone's faults
2 try to pay attention to people when they are talking to you
3 ask questions

Has there been a shift in etiquette as the financial climate has changed?

yes—people seem more open to collaboration, more open to beginning new conversations.

What constitutes bad manners?

not paying attention.

What is the role of etiquette in the art world?

That the art world should have a separate code of behavior from civilized society serves to indicate its self-impressed and savage nature.

Was etiquette foregrounded in any memorable situation?

During graduate school, there was a professor with whom I wanted no contact, personally or professionally. This was based on prior casual interaction. Contact wasn't required, but in my third or fourth semester, I was the only person in my class who hadn't met with this person, and "people" were "concerned" with my "behavior." So we had a "studio visit," and it proved more useless than I'd anticipated. "Etiquette" trumped intuition, and time was wasted. This sounds rude on my part, and maybe it was, but basic human feeling should never be ignored for "networking" reasons. You don't go on dates with persons to whom you're not attracted, even if they're offering you, as Beck says, "a real good meal."

What customs or mannerisms are particular to the art world?

"What are you working on?"
"Blah, blah, blah, space, blah."
"Oh, interesting, OK, great."

How should people behave? What would be a maxim for appropriate conduct?

People should behave like Tracy Williams. Her openings are enjoyable to visit. There are two floors to navigate, two different feelings. The work is usually good. There is sometimes decent wine in real glasses. She is accessible and seems actually proud of the work. It's genteel, and respectable, and relaxing, almost like visiting your Aunt Edith in her chic DC apartment.

Slaven's maxim: I talk to people I like.

What constitutes bad manners?

Bad manners = bad memory. Also, aggressive "networking" = bad manners. Pretending to not engage in "networking," while "networking" = bad manners.

Has there been a shift in etiquette as the financial climate has changed?

If money changes manners, either by gain or loss, you were losing anyway.

Etiquette is a set of rules that govern the performance of self. Like all performances delivered in the nebulous context of art, the performance of etiquette has implications that are far-reaching and unpredictable. Indeed—from my perspective as a young artist and curator—perhaps the most challenging characteristic of art-world etiquette is the frequency with which codes of behavior are transgressed and the unreliable results of such transgressions. Outlandish activity is excused in some artists that would permanently mar the careers of others; often, such acts would certainly be unacceptable outside of the art world. To wit, a friend's Facebook page labels him the "BADDEST-ASS artist on the planet." I couldn't get away with a statement like that. My practice doesn't permit it. And it goes without saying that an aspiring corporate executive could never similarly blow her own horn—not in so many words. But in the instance of my friend, whose work involves outrageous displays (and critiques) of ethnic masculinity, blatant acts of self-aggrandizement only operate in service of his career. Anything can be justified if it forms part of a legitimate conceptual approach. If an artist's MO is bragging about his own strength, he is expected to do so in any appearance: it authenticates performances delivered in designated art spaces and satisfies stakeholders of his total commitment to his practice. In fact, I have noticed sometimes an artist who plays strictly "by the books" risks appearing academic, overambitious, or worse, square, when compared to those who make their own rules.

There are times when real-world etiquette would bring welcome simplicity to messy art-world situations. Take unwanted sexual advances, for example. Suppose—just for the sake of conversation—that a mentor touches you inappropriately. To reject his advances may seem straight, boring, unworthy of your progressive temperament as an artist and freethinker. To accept, though, is equally unimaginable: does the other party consider you easy? Or even more horrifyingly, was this person's support hollow all along, girded by sexual attraction rather than your irresistible talent?

When I entered an MFA program—my first exposure to the conventions governing the formal study of fine art—I found that with studio visits and critiques came a set of etiquette challenges totally unique to the art world. When is generosity called for, and at what point does it become unhelpful or even unfair? What if you don't like your best friend's chartreuse sculptural paintings? Not quite the same as disapproving of her cubicle.

In the context of post-Conceptual art, where artwork can scarcely (if at all) be distinguished from the artist as a person, value judgments have implications far beyond the simple assessment of a painting or an object. An artist is the accumulation of the material (or immaterial) art works that she makes, the way she talks about the work, and her entire public presentation of self. Building a career as an artist is a bit like an extended run for political office;

not only are your intellect and creativity permanently on trial, but everything you've ever done is fair game. Avoiding a career-busting etiquette misstep—or failing to take proper advantage of a career-boosting opportunity—requires constant vigilance.

Should I go say hi? Sure why not... actually I probably shouldn't... well... if I don't go say hi I'll look like one of those pretentious snobs... which of course I'm not... I should go say hi, even better, I should have a drink and then go say hi...

...Oh... he looks like he's about to leave... leave with the impression that I'm one of those people that pretend they don't see you and don't say hi... so not me, the nice straightforward type... ok gulp down this drink and then sashay across the room and make a funny remark about something and say hi...

...well... by now it's kind of stupid... after an hour of bumbling around in this room full of people who know each other but pretend they don't... and now he thinks I'm just like them, not the easygoing straightforward type... which clearly I am...

...Getting ready to casually go over there and small talk myself into a witty repartee...

...wait... what if he doesn't remember who I am, that would be awkward... clearly belonging to the overeager type, the trying-to-be-witty type... so not me... or is it... I'll have another quick cocktail and weigh the options...

...ultra-eager pseudo-wittiness versus thinks she's too cool to say hi–ness... hmmmm... tough one...

...Well the stakes aren't that high... after all... I should go say hi, yes... going right over there for a nice hullo, what've you been up to...

...no no no definitely not what've you been up to... that one should be erased from the books pronto...

...right... just a quick one for the road and I'm off...

What are the rules of etiquette for the art world?

It's like that photograph of John Baldessari standing with his back to the palm tree with the word "WRONG" printed beneath it: any amateur photographer knows that it's a mistake to snap a picture with a tree growing out of someone's head, but then again, who cares? Why is that a rule anyway? Who makes these rules? Are there rules for art or even behavior in the art world? Why does one charming, attractive, talented, artist/dealer/critic/curator fail miserably, while one whose diseased dog's tumor explodes on the backseat of his dealer's brand new Prius triumphantly succeeds? This only underlines the fact that, no, there are really no rules.

But there are guidelines. The guidelines for behavior in the rarefied air of the art world ultimately relate to furthering the promotion and distribution of the work. Being able to be witty with collectors, museum patrons, reporters, and the public is pretty darn helpful—but then again, there's that tumorous dog. Rather than write an exhaustive list for every situation, which is perhaps above my pay grade, I'll concentrate on one situation in detail—though again, these are only guidelines and can be promptly ignored. This is an incomplete list of situational aesthetics.

Guidelines for Openings:

1 You must attend openings. When you're Bruce Nauman, you can be a hermit in New Mexico. Until then however, you have to attend openings. Why? If you're young, it's important to find out how things work, to meet your colleagues, to find out what's out there in the world, and ultimately, perhaps, to learn how to behave at openings. If you're mid-career, you must go out to support the colleagues you met at the earlier stage of your respective careers. If you're older, it's important to support colleagues, still, but now also students, and or other members of the younger generation who will see you as a mentor. Other slightly noble reasons: if you're obsessed with art and you have to see things as soon as you're able, and if you really, honestly, love art—talking about it, interacting with it, talking to people responsible for making, distributing, promoting, and critiquing it. If you love it, then it's not work. Artists, critics, and curators stay vital when they're interacting with their peers. If you're young and you hate openings, there's a noble history of outsider artists living in insane asylums and working as janitors who are discovered long after they've died. If you're old and you hate openings, it's likely your best years are behind you, and you think all art but the stuff you and your peers made is shit. I hope your few years of past relevance allow you to retire to your television.

2 You must greet and congratulate the dealer and the artist(s) at the opening. All other greetings are situational: a friendly nod if you catch somebody's eyes is completely acceptable, as are a passing pat, an air kiss, or any preferred method of casual greeting in a crowded opening where you may know half the crowd.

3 The dealer is required to provide alcohol and non-alcohol to all the guests. This can be as simple as a tub of beer and bottled water. It can be fancy wines and freshly squeezed juices, cheese platters, and a bow-tied bartender. There ought to be alcohol for at least the first two hours of a three-hour opening. The last hour is usually best, but not if there's no alcohol.

4 If the dealer and/or artist(s) ask you how you like the show during the opening, try to find something polite to say. If they insist on a real opinion, they've got whatever you have to say coming.

5 Be briefed on at least three recent things that you can be congratulatory about: recent exhibitions seen and enjoyed, exhibitions you would like to see and enjoy but have not been able to make yet for whatever reason, recent successes by colleagues.

6 If you're an artist, critic, or curator, someone will inevitably ask you what you're working on. It's good to have either two projects that can be mentioned briefly, or one project that can be mentioned in more depth—though still kept within the bounds of appropriate party chatter. In different cities, artists, critics, and curators take different tacks on describing their workload. In Los Angeles, artists must always look like they are rested and fresh. In New York, the more haggard and hardworking you look the better. It's always appropriate to be on your way to or to have just returned from international travel, e.g., "I just got back from being in this biennial in Prague, but I've only a couple of weeks to get on my feet before I have to have some meetings in London."

7 Usually the rapid coming and going of people at an opening allows for quick conversational turnover, but if you get stuck in a bad conversation with someone and you're outside, say, "I'm just going to pop in and look at the show." If you're inside, say, "I'm just going to pop out for some air/a cigarette." If they're still following you, go to the bathroom.

8 If you don't know anyone at an opening, (unlikely after a few years going to openings but nevertheless), then it's relatively easy to engage with people looking at the work or at the beer bucket. The more people you can attend the opening with, the easier it may be to weave yourself into the social web.

9 Try not to get too drunk on the cheap white wine/cheap beer at the opening: afterwards, at the bar or at dinner, it's more acceptable. But you still have to be able to walk out of the bar at the end of the evening. Unless, of course, you don't want to, in which case you can likely get away with being a drunk for many years as long as you don't punch people too often.

10 The dinner after the opening can only be attended if you're invited formally, beforehand, or by the dealer or artist during the opening—except if it's a very wealthy gallery having a very large dinner where no one is sure who's invited and who isn't, and you know a few people there. Somebody always doesn't show, and either way you're welcome to stay at the bar or smoke outside while things mix up. N.B.: this only works at certain restaurants. In Los Angeles, the best place to crash is Dominic's.

11 Whoever you sit next to at the dinner determines your rank in the pecking order, according to the gallery. If you sit next to the artist, it's likely you're wealthy, the artist's best friend, or an important curator. If you sit behind the potted plant next to the artist's third cousin, it's likely you're a critic. This can be accepted temporarily—as the dinner breaks up, there is great mobility in seating arrangements. (This is dependent on the size of the dinner and the choreography of the event.)

12 Business can always be discussed at openings and dinners, provided you observe the protocols. Artists can never directly invite dealers to visit their studios, unless a strong rapport has already been established. Artists can, however, talk about what they're working on, and the excitement that others have for the work, e.g., "I just finished the installation about Hekabe with the really ornate collage. Hans Ulrich stopped by on his way through and said it looked like Vito Acconci on acid." Curators can corner dealers for specific works. Critics can, and should, get whiskey for free.

If there was one underlying rule in art world etiquette, it would be this: you have to interest others in what you're doing. This applies to everybody in the end. Whoever the others are, or how you attract them, is up for debate. Some are cloying and aggressive, others haughty and aloof. As always, doing great work is the best way to attract—though what constitutes great work is invariably also up for debate. The purchasing and appreciation of visual art is about propinquity to a visionary, closeness to generative genius, an ability to have in your home or museum the artist's gesture made permanent in a displayable object. Van Gogh is likely to have stepped onto your Louis Quinze sofa with muddy workboots and pissed all over your sleeping grandmother; this does not make him a better or worse artist than the more genteel Gauguin. Van Gogh sold only one painting in his lifetime, though he now enjoys catastrophic success above all his peers on every measurable level.

This is perhaps not the model most young MFAs are shooting for. Lesson: misbehaving artists tend to do better postmortem. So it goes.

Was etiquette foregrounded in any memorable situation?

The weirdest situation I've heard of in this regard involved an artist getting a visit from some Whitney Museum curators, who were trolling for artists for the biennial. The curators read books covered with paper so that no one could see the titles. When the artist's dealer asked how they'd heard of the artist, the reply was "We have our ways." When they visited the artist, they said almost nothing. Their only question was where the artist had gone to school. The rest was a song-and-dance routine. Where these rules came from I can't say, but they seem so rigid that somebody, somewhere had to make them up.

What customs or mannerisms are particular to the art world?

The customs specific to the art world are in regard to the cultural importance of the work itself. There is always the pretense that art is different than other cultural activities. Its various sectors have their own take, and push their own agendas. A curators' and critics' darling may have a hard time early on in the marketplace, but if they endure, their work will be worth invariably more than some pretty young gay painter—no matter how much the market may be skewed in the painter's favor on the front end. Behaviorally, the assumption that guides all activities is that the art is different than pork bellies. Though some people have had very successful careers trying to erode this difference.

When does breach of etiquette play a role in embarrassing or awkward encounters?

This question is quite odd to me, because, as a critic, I'm usually considered the enemy. You can wine and dine me when appropriate, invite me on press junkets, offer me access to the artist, develop a friendship with me over years of interaction and sometime collaboration, and I'm still expected to be independent: potentially, to trash any show I see, either in print or in conversation. If they care or know enough, dealers and curators might try to cultivate a friendship, and this may mean that I will always look, but what opinion I come to is all my own. Critics, if they're any good, are around and involved in the social interactions, friendships, conversations, and engagements that make the creation of art happen—but how they feel about a person is separate from how they feel about the work.

Some people have seen this independence as a breach of the social contract. Those who tirelessly advocate for artists hate a bastard who can offhandedly dismiss their efforts as derivative. This has lost me girlfriends and gained me quiet letters of affirmation from the like-minded. It has caused dealers to try to have me fired and gotten me thrown out of parties. I'm sure someone will knife me in an alleyway for a rough review one of these days. Social awkwardness is built into my role, as it comes

into direct conflict with the roles of others: the advocacy of art through sales, patronage, or publicity.

How should people behave? What would be a maxim for appropriate conduct?

When I first got involved in the art world, before I had any real say or place in the conversation as a critic, people were nice to me—not because I had something to offer them but simply because I was a human being. It sounds almost too plain, but people should behave as if all these people were human beings, with efforts and problems and dreams, and even though some aesthetic effort may look trifling, that trifler still needs to be dealt with fairly and honestly.

Has there been a shift in etiquette as the financial climate has changed?

People are less strident now that there's no money. Artists are more generous with their time and efforts, dealers less generous but with a higher propensity for flapdoodle. Artists no longer expect a full-page ad in *Artforum,* a lavish dinner, and a big production budget. No one has the money anymore to do it all. Before, artists always had to keep up the veneer of success, but now, working day jobs openly is more acceptable. Teaching jobs are sought after rather than complained about. Dealers no longer have to keep up with the Joneses by going to countless art fairs, and not applying to Art Basel doesn't mean you'll never get in again anymore. The parties have become much more fun, less about hiding or baring success and more about honest interaction—though there are fewer of them and the quality of the booze has dropped.

What constitutes bad manners?

The worst person I ever met in the art world, a backstabber, a social climber, a racist, a gold digger, a tireless opportunist regularly hiding behind the veil of PC niceties, a person who always treated her underlings like dogshit stuck to an expensive shoe, who licked her overlords' assholes with relish as long as they had money, influence, or fame, is now an important curator at a prominent New York museum.

What constitutes bad manners is relative.

Is the art critic Jerry Saltz really my friend? I ask myself this every time I see his picture on the Facebook application "People You May Know." I know him. We have chatted and exchanged opinions on art or politics in a passerby moment during an opening or at the gallery. We have 43 mutual friends, which must make him my most mutually friended non-Facebook friend. But do we know each other well enough to be Facebook friends? Well let's see. It is 3:01 pm on Thursday, and I have just clicked "Add as Friend" with no personal message attached. His Facebook picture is a bit intimidating. He is standing with Bill Clinton or maybe just a cutout of Bill Clinton. Either way, it makes it clear that he has higher Facebook ambitions. Friendship confirmed at 3:47 pm the same day. I wonder if Schjeldahl is available to IM?

Social behavior at gallery openings is the same as at any other gathering where there is drinking and many of the people know each other. People know how to behave at parties, so that isn't a problem. What causes an etiquette problem is the presence of the art objects, which are the ostensible reason for the gathering. Some people solve this problem by ignoring the art. They glance at it or are dimly aware of it in their peripheral vision while they scan the room for people they want to talk to or for the wine and beer table. They usually find the artist or artists and manage to say something nice, but that has nothing to do with looking at the art.

Since it is the existence of the art objects in a gallery space that turns art world etiquette into a problem, the question arises: How long do I have to look at these things to show I am interested in them? If I am uninterested in them, which is often the case, I know almost immediately. Should I feign interest and study them for longer than I want to, hoping I will come to some sort of understanding or subconsciously store enough information to have an epiphany later? Must I try to show an interest I do not have? Or do I give each art object the three seconds I think it deserves and move on?

Trained by movies, we can take in a huge amount of visual information at once. We are used to seeing 24 subtly different pictures a second, so a lot of the time three seconds is plenty. Sometimes it's too long. Sometimes if you looked at something for four seconds you would have to go over and punch the artist. There's a lot of bad art, but that hardly ever happens. I think that proves people understand good manners, and that good manners are a problem in the art world.

If I like the art, the etiquette question is just as tricky. What if I am having some kind of life-changing experience seeing an art object? Do I stand there and gawk, holding up the line? Do I shout and point, overwhelmed and unable to contain myself? Do I look at the things I like briefly and make a mental note to come back during the show's run and look at length when fewer people are around? Of course, I know I may not have the time to do that—I may not pass this way again. So that is a form of disingenuousness, too.

These questions are further complicated at art openings by having to listen to other people's comments about the art, which you can for some reason better ignore in a museum or in a movie line but which grate at art openings. Stupid or banal comments scream out at you like air-raid sirens at art openings because so many people feel obligated to say something instead of just scanning the room and getting their wine. They force themselves to say something before they allow themselves a drink. This is why museums will survive. Until they all have video monitors next to each artwork showing an explanatory documentary about it, which I predict will happen in our lifetimes.

What are the rules of etiquette for the art world?

Are there any? Every little art-world group makes its own rules. Sometimes it's OK to do drugs in the gallery. Sometimes not. Sometimes it's OK to talk about money. Sometimes not. The only hard and fast rules might be that people like to talk about etiquette and what should and should not be done. But no one ever does anything about it. Etiquette is strictly a conversation and relative to each situation.

What customs or mannerisms are particular to the art world?

The custom of standing in a crowded room where you can't see anyone or anything, for no other purpose than to be there.

When does breach of etiquette play a role in embarrassing or awkward encounters?

Once, someone who wasn't friends with the artist tried to eat a lot of the artist's pizza. But that seems minor and fairly common. In certain circles that is acceptable and even encouraged.

How should people behave? What would be a maxim for appropriate conduct?

If I had a fondest wish it would be that people would refrain from handing out their own postcards at someone else's opening. This makes me uncomfortable. And that people would pay on time.

Has there been a shift in etiquette as the financial climate has changed?

No. Just a shift in perspiration.

What constitutes bad manners?

Violence, passing out, vomiting, hoarding all the beer. That's about the worst I've ever seen. The art world(s) is/are a pretty tame thing.

James T. Mangan, in his Dartnell book, *The Knack of Selling Yourself*, lists eight prime qualities you need in order to sell yourself, and these, in the order of their importance and in the chronological order in which you should go about acquiring them, are as follows:

1 Expression
2 Promise
3 Guts
4 Approach
5 Diplomacy
6 Familiarity
7 Reliability
8 Persuasion

Briefly, here's what each means.

Expression consists in taking everything that's inside you—your spirit, your emotion, your intelligence, and all the rest of your ability—and seeing that it definitely gets outside you, to reach as large a number of people as possible. Work on expressing yourself via speaking correctly, learning the art of good conversation, writing how you feel naturally, showing enthusiasm, helping people feel as you do.

Your promise is simply the size of your future. Never use the past tense! Look, work toward, believe in the future, and have a plan for getting there.

"Guts" is an offensive word to some people. "Nerve" or "courage" might be nicer. But vulgar as "guts" may sound, it describes a quality that is so important in establishing your individuality that it must be placed third on your list of essentials. Be bold, stand on your own feet, stick to your guns in the face of adversity, rise to your full height, take heart, be a self-starter. All of these characteristics are found in one who has "guts."

Approach is the art of making contacts. Every time you make a contact, make it! Develop an "approach personality" by making a list of the names of people and customers who mean something to you, getting a reputation for quality performance with these people, keeping in touch with them, studying the successful approach methods of others, putting yourself in the shoes of the individual you are currently in contact with, learning how to get things done through people. Your approach is a key part of good customer contacts.

Diplomacy is the art of using people, things, issues, and events to serve your own purpose. The key to all diplomacy is patience. Don't get upset quickly, pay compliments, don't say what you think if it shouldn't really be said, render praise, give attention, show gratitude, be considerate. All of these qualities are found in the diplomat.

Familiarity is the ability to put yourself in the other person's family. If you can do that, he will treat you as a brother. He will feel safe in dealing with you. You will belong to his class. But watch yourself here—don't get too familiar too quickly! Don't be pushy and don't start throwing first names around. Keep in mind the old cliché, "Familiarity breeds contempt." That's only true when it's pressed. True familiarity breeds confidence, understanding, good will.

Reliability is a necessary quality in selling yourself. But in order of importance it is down the list. However, if you don't carry the marks of reliability, other assets can fail. Tell the truth, keep promises, don't be two-faced, avoid tricky dealing with others.

You get other people to act by forcing them to act—not by physical force or threats, but by persuasion. Aim at the customer's needs, help him attain what he really wants, show him good examples. Inspire others to act! That's selling, and no matter what your job is there is always a certain amount of selling involved. Brush up on your sales ability.

(From Customer Contacts, A Monthly Memo Book to Help Those Who Meet the Public, February, 1963)

What are the rules of etiquette for the art world?

May I make a recommendation instead? Something from the Emily Post "school" of etiquette which I think the art world would certainly benefit from is the exchange of more thank-you notes.

Was etiquette foregrounded in any memorable situation?

I know a dealer who truly believed he was punishing an established curator (who had interfered in a sale) by removing him from the gallery's email list.

What customs or mannerisms are particular to the art world?

People kiss and hug when they see each other oftentimes after just meeting one time prior. I don't think this happens in most professional spheres, such as say, the medical or legal.

This isn't to say the kissing and hugging lasts forever. These same people could easily ignore each other months later.

When does breach of etiquette play a role in embarrassing or awkward encounters?

At totally separate times two prominent art dealers for whom I was working audibly farted while dictating a letter aloud as I typed. Both had the exact same instinct—to mask the noise (immediately after the fact) by speaking much louder and more authoritatively. Both times I blinked, but otherwise pretended not to notice a thing.

How should people behave? What would be a maxim for appropriate conduct?

People should behave as if this moment of the art world is not the only one that matters.

Personally, I think back to high school... I think about how I wish I acted then (less insecure, more self-respect, kind to everyone, but being able to stand up to the mean girls), and then I apply that to how I act now.

Has there been a shift in etiquette as the financial climate has changed?

I've definitely noticed different facial expressions and body language.

What constitutes bad manners?

Bad manners are the result of someone forgetting that the art world is a community, for the most part made up of people who are both sensitive and hardworking, and selfishly ignoring the feelings and efforts of others. Additionally, bad manners are the result of unstable people acting manic... sometimes it's hard to tell the difference... especially when drugs are involved.

BOB NICKAS
ANCHORS AWEIGH
SOME ADVICE FOR THOSE ABOUT TO ENTER...
SHOW BUSINESS

1 You cannot exhibit a work of art without good reason. To do so is to have abducted an object. Any text you write is thus no better than a ransom note. Ask for your fee in unmarked bills, no larger than twenties.

2 Never, ever exhibit a work of art in a show in which the artist has not agreed to take part. Unless the artist is dead, without an active estate, and you honestly don't believe in the afterlife.

3 You can't sail without an anchor.

4 When placing the work of two artists in relation to each other, avoid three-dimensionalizing pictorial elements. If an artist wants to construct a picket fence and place it on the floor in front of her painted landscape, she can surely do it by herself. Your *mise-en-scène* is nothing more than mis-representation. The hybrid "third work" is a myth.

5 Do put works next to each other that wouldn't in a million years seem to belong together. You probably won't have seen it before, and if a suggestive space does open up between them, no one has to know it was a shot in the dark.

6 "You don't need permission to participate in culture."

7 Only go to openings if you're invited.

8 If you do sleep with a young artist, you must be convinced that his work will be of interest to others, and for more than a season. After all is said and done, it is the exhibition that should be well-hung.

9 Of the 60s, Andy Warhol once said, "You were never sure whether you were getting to know the person or the drug the person was on." Think about this when offered cat tranquilizer.

10 The only reason to tell someone you liked his or her show is if you did.

11 Keep your honest opinions about art reviewers to yourself. Otherwise, your shows will be panned or ignored in the local papers, as will the work of those artists you support. Objective journalism and petty retaliation are not entirely incompatible.

12 Gifts from artists are only acceptable if the gesture acknowledges sincere appreciation for something you have done, rather than for what you will do. Gifts are not bribes.

13 Artists you have selflessly championed for years who give you nothing are cheap.

14 Experience is to be found in the everyday, in the world in which we live. The "monastic retreats" of Pasadena and New Haven are symptoms of withdrawal. Wave a white flag and go to sleep.

15 The Unconscious is to be explored thoroughly as the only site of truth-magic available to you free of charge, night after night. Remember, dream time is prime time.

16 If you don't have a TV, get one.

17 When you're paid to write by the word, keep in mind that footnotes don't count.

18 Get half your money up front before you push even one single piece of paper, and if you don't have an agreed upon "kill fee," you're dead.

19 Life is no performance.

20 If you curate shows and you also make art, you are absolutely disallowed, under any circumstances, to include yourself in your shows. Those who do should be flogged, pants down, in the town square.

21 The public, as a rule, doesn't like public art.

22 "Art is to change what you expect from it."

23 No matter how grievous your crimes—financial, ethical or spiritual—everyone has nine lives in the art world. Christian forgiveness is alive and well. Amen.

24 Try to remember that you are at play, not a power player, and in the end we are, every one of us, reduced to dust. So you're going to be finer and more powdery. So what.

25 If all else fails, have fun and fuck things up.

Of all social forms, I find proper introductions to be the most difficult. The combination of unarticulated expectations, conventions, and motives creates great potential for unparalleled awkwardness. Within the art world, this form is made even more complex by the ambivalence with which the art community views professionalization. In less rarefied social contexts, simple devices, such as the name-tag, are used to ease the difficulty of introductions. Featuring the bearer's name, corporate or group affiliation, and a generically indiscriminate greeting, the name-tag is perfect for situations in which nobody knows anyone, and everyone has a reason to meet. At a business-networking event, getting to know unfamiliar people is the sole reason for attendance. Consequently, introductions tend towards transparency, straightforwardness, and functionality—in contrast to the complex and ambiguous encounters typical of art world openings and parties.

Many people I know have a particular manner of making introductions and even preferences for how they themselves are introduced. For example, certain friends insist on no introductions beyond their first name. With great faith in social predestination, they believe that innate affinity and mutual interest will either create a dialogue spontaneously or allow a given interaction to end quickly of its own accord. I remember from my years in Berlin an oft-expressed rule: avoid introducing oneself by full name or discussion of work, as it is crass and professional. While I admired the principle of this stance, it sometimes led to absurd situations. Once after playing pool for several hours with a group of friends and new acquaintances, I was dismayed to discover that a member of our group was a well-known artist whose work I had admired for years. Of course, by then it was too late and too awkward to even mention this fact.

Among artists in New York, I've more often experienced formal introductions by first and last name, paired with carefully-chosen references to each party's best-known or recent work. On the one hand, such introductions can be inclusive by encouraging fluid interactions and mingling distinct social circles. However, even when sincerely made, these introductions often veer towards comic effusion in their valiant attempt to engender an instant conversational connection: "This is so-and-so, they are the most amazing whatever in New York. You must have seen that project last year, it was so well-received, no?" While potentially providing a basis for meaningful discussion, such introductions are tricky: they involve acquainting people who ought to already know each other's work, but by virtue of the necessity of an introduction, most likely do not.

Finally, a familiar form in the art world is the goal-oriented introduction, in which one attempts to facilitate social contact on behalf of a single party. Such situations are functional and professional, but, in order to be effective, must observe the

protocols of more informal encounters. The set-up is simpler because desire in these cases is purely one-sided: as a means to an end, one person wants to meet another, who likely has no prior knowledge of them. For example, I'd like to introduce my friend, an artist without representation, to a gallerist with whom I've worked in the past. Here the onus is most clearly on the introducer, who attempts to reveal a relevant piece of information that will pique the interest of the targeted party. Perhaps my own social awkwardness is to blame, but I've routinely seen this stratagem fail, most often with the mark either ignoring the introduced party or exiting the situation entirely for the drink table or restroom.

Given the impossibility that I'll ever be introduced to or introduce anyone appropriately, I may have to hope for the next best thing: an unregulated, alcoholically-lubricated world of social contact, in which introductions are neither needed nor desired—where everyone wears their hearts (and name-tags) on their sleeves, allowing conversation to sometimes ebb and often flow.

DAVID LEVINE

What are the rules of etiquette for the art world?

As international as it is, it depends on the city. In Berlin, the rule is don't be a jerk; in New York, you're supposed to be a jerk, but politely. [see below]

Was etiquette foregrounded in any memorable situation?

An artist is curating an exhibit in a project space. I go to the opening. I join him, another artist, and a "full" curator (whom I do not know) outside. They are all bitching about someone else's work. Eventually, the artist-curator walks away. Everyone mocks him mercilessly. But we were polite enough not to do it to his face.

"Full" Curator then starts bitching about people sending him unsolicited submissions, emailing him every time they have openings, etc. etc. etc. I defend such conduct, but Artist B hedges her bets. Curator walks away. Artist B and I mock him mercilessly.

So I have, in rapid sequence, been introduced to an influential curator, bonded with said curator, and been disgusted by said curator, all through the medium of mockery. And by refraining from notifying him of upcoming shows, I am honoring both his sense of etiquette (don't bother me), and my own (don't fuck with jerks).

What customs or mannerisms are particular to the art world?

In this scene, as opposed to, say, the movies or TV, there's no premium placed on sociability—the art of making those around you feel comfortable (not to be confused with socializing, which is obligatory). Therefore, some of the most insecure, defensive, aggressive, or just plain awkward people become the most successful curators, artists, and critics. Because in this setting, discomfort is convertible to status, and so the art world becomes a paradise of social ineptitude, whose continuity is ensured by offering none of paradise's rewards.

When does breach of etiquette play a role in embarrassing or awkward encounters?

I'm not sure this is etiquette, exactly. But imagine an opening in Berlin—a group show—and a not-great, tension-based sculpture (box on the ceiling, being held shut with a fourteen-foot bamboo pole wedged between the box and the floor). Someone, of course, is going to knock into the pole sooner or later. But in this case, it happens to be a mildly retarded, middle-aged man in a wheelchair. All of a sudden this guy is covered with sawdust, shrieking, slapping his hand violently against his legs, going "WAS IST DAS DENN?! WAS IST DAS DENN?!"

Was it a breach of etiquette for the artist to court such risks?
Was it a breach of etiquette for the victim to react so violently?
Was it a breach of etiquette for the artist not even to notice that something had happened?
Was it a breach of etiquette on the part of the spectators, who thought it was a performance and so refused to take the incident seriously?
The only person not implicated in this total, systemic

breakdown of etiquette was the gallerist herself, who went outside, grabbed the artist, dragged him over to the guy (still screaming and crying), and forced him to apologize to the poor man and his attendant. She was the only one who seemed to have any sense of context, social cohesion, or necessity (but that's liability for you).

How should people behave? What would be a maxim for appropriate conduct?

Try to make those around you as comfortable as possible. Try to ignore apparent slights. Remember: everyone is totally freaked out all the time.

Has there been a shift in etiquette as the financial climate has changed?

A shared hopelessness seems to have taken the edge off exclusionary conduct. So now it's "We're all in this together," as opposed to "We're all in this together... and you're not."

What constitutes bad manners?

Getting so caught up in your own social discomfort that you fail to attend to the comfort of others.

What are the rules of etiquette for the art world?

This may sound nonchalant but I really think the art world is like any other world. Everyone wants to be included, most people are insecure, some people are bullies, some people are very lovely, some people are active, some people are lazy. I really don't think there is any one way to behave. People are impressed by others' knowledge and their ease.

What customs or mannerisms are particular to the art world?

In my experience, a lot of emphasis is placed on mystique. People who are effortlessly in the know. That probably doesn't make any sense.

How should people behave? What would be a maxim for appropriate conduct?

Um, people should behave how they want to—of course there is not a specific way to behave. I mean, everyone hates it when someone says, "My five year old could have made that," but beyond that—go crazy. For myself, I try to be open-minded and gracious. I'm sure I'm not always successful, but the people I respect most are gracious.

Has there been a shift in etiquette as the financial climate has changed?

I don't know if it's because of the financial climate or because I now operate a new small gallery, but there are a select few that like to try to tell you "how it is." "How it is" is usually the whole art world is collapsing so you must slash your artists' prices by ¾ or even give them free artwork so they can help promote it for you. There are people trying to take advantage because they think they can have bad manners right now, and everyone will take it because people are so desperate for anything to happen (i.e., to make a sale). The same thing is happening everywhere—companies are doing shitty things to their employees and blaming it on the times. This is a time where we should be coming together, but for some it's a time where they can eke things out of people or kick people while they're down. That being said, some people are truly supportive and upstanding. There are people that have scope and grace and know that it's the natural law that things go up and down. What's important is that we are all still able to do what we do.

What constitutes bad manners?

Again, I don't care about manners in terms of personality. People can be however bold or shy or awkward or obnoxious or whatever. I guess I care about it in terms of ethics.

What are the rules of etiquette for the art world?

Impossible to sum up because the art world is a "where worlds collide" kind of place—people from different social strata, of different generations and countries, etcetera, make etiquette a constantly shifting and constantly negotiated thing. Which is good.

How should people behave? What would be a maxim for appropriate conduct?

My Japanese stepmother tells me there's a word that describes a particular kind of effort by which one invests "real feeling" into the formal practice of etiquette—a kind of "make it real" idea which appeals to me. I don't, however, think etiquette should always supersede injecting real opinion, bluntly stated, which may be read as rude and hurt feelings. My socioeconomic background as a New York Jew taught me this a long time ago. Sorry and Fuck You.

Has there been a shift in etiquette as the financial climate has changed?

Perhaps, if the downturn turns even downer, the art world will belong again to the artists (that's the hope, at least). We might, then, be outsiders once more and etiquette amongst outsiders is always interesting: sui generis with the possibility of being simultaneously more raw and more refined.

What constitutes bad manners?

I would love to write an essay on the etiquette of Bad Manners, which has been part of the artist's "job," so to speak, for a long time, starting with the court jester, perhaps. There are "good" bad manners (Dick Bellamy's famous naps in corners of four-star restaurants when feeling bored or "drowsy," and Richard Serra's equally famous public and personal diatribes [is it something about being named Dick?]) AS OPPOSED TO the "bad" bad manners on display by Alex Bag recently at an EAI presentation/screening event of her work: she scarcely looked at the audience, made arch and contemptuous remarks throughout the evening, had an extended burping-into-the mike moment, etcetera, etcetera. Although I have to say I enjoyed it (particularly the shocked silence of the thirtysomething academic types in the audience), it wasn't a noble kind of rudeness: it spoke more to Bag's insecurities and essential weakness than to any kind of true outrage/challenge to the social order which takes courage and belief in ideas and oneself.

What are the rules of etiquette for the art world?

It depends who you are, some people make rules, others break them, some both.

Was etiquette foregrounded in any memorable situation?

Since many times most involved are all uptight about this very construct of etiquette, inevitably someone slips. And not just metaphorically.

What customs or mannerisms are particular to the art world?

drink, drink, drink too much

When does breach of etiquette play a role in embarrassing or awkward encounters?

never that embarrassing, the art crowd can be very forgiving, or forgetting.

How should people behave? What would be a maxim for appropriate conduct?

Never been one to like requirements on how anyone should be. Me personally, stay being yourself no matter what or whom.

Has there been a shift in etiquette as the financial climate has changed?

Yes, people are a bit friendlier, a bit more time on their hands.

What constitutes bad manners?

Offending someone for no good reason. And there usually is no good reason.

Artists must first of all distinguish themselves from members of the adjacent professional classes typically present at art world events: dealers, critics, curators, and caterers. They must second of all take care not to look like artists. This double negation founds the generative logic of artists' fashion.

The relationship between an artist's work and attire should not take the form of a direct visual analogy. A stripe painter may not wear stripes.

The relationship between an artist's work and attire should function in the manner of a dialectic, in which the discrepancy between the personal appearance of the artist and the appearance of her work is resolved into a higher conceptual unity. An artist's attire should open her work to a wider range of interpretive possibilities.

The artist's sartorial choices are subject to the same hermeneutic operations as are his work. When dressing, an artist should imagine a five-paragraph review of his clothes—the attitudes and intentions they reveal, their topicality, their relationship to history, the extent to which they challenge or endorse, subvert or affirm dominant forms of fashion—written by a critic he detests.

Communicating an attitude of complete indifference to one's personal appearance is only achievable through a process of self-reflexive critique bordering on the obsessive. Artists who are *in reality* oblivious to how they dress never achieve this effect.

Whereas a dealer must signal, in wardrobe, a sympathy to the tastes and tendencies of the collector class, an artist is under no obligation to endorse these. Rather, the task of the artist with regard to fashion is to interrogate the relationship between cost and value as it pertains to clothing, and, by analogy, to artworks.

An artist compensates for a limited wardrobe budget by making creative and entertaining clothing choices, much in the way that a dog compensates for a lack of speech through vigorous barking.

Artists are not only permitted but are in fact required to be underdressed at formal institutional functions. But egregious slovenliness without regard to context is a childish ploy, easily seen through.

An artist may dress like a member of the proletariat, but shouldn't imagine he's fooling anyone.

The affluent artist may make a gesture of class solidarity by dressing poorly. She is advised to keep in mind that, at an art opening, the best way to spot an heiress is to look for a destitute schizophrenic. Middle-class or working-class artists, the destitute, and the schizophrenic can use this principle to their social advantage.

The extension of fashion into the violation of norms of personal hygiene and basic grooming constitutes the final arena for radicalism in artists' fashion. Brave, fragrant souls! You will be admired from a distance.

ARTFORUM
MARCH 2009

REVIEWS

*2009. From left:
Bridges among water,
2008; Run in front of
your shadow, 2008.*

The awkwardness involved in physically negotiating ████████
██████ "Owl" was surely no accident, ███████████ knowing this made
the viewing experience more fulfilling ███████████████ her
sculptures ██████████████████████████████ made a case for
active engagement ███
████████ worked-out ideas. Shoehorning several concerns—each of
them independently complex—████████████

████, in close quarters, ██ Brooklyn-
██████████████ did not match them with a
coherent cumulative vision.

The exhibition consisted of eleven raw,
variously sized, wooden pedestals, each
painted on one side with vivid stripes.
Atop each ████████ is a small acrylic paint-
ing on panel, held upright by wooden sup-
ports. These simple, square compositions
are ██████████████████ divorced of their
sculptural supports
████████. The show offers █████████
██████████████████████████████████
██████████████████████████████████
████████████████████████ reasons
for including all these components, but it
remains difficult ████████████████████
██████. And ███████████████████████
██████████████████████████████████
██ much ██████████████████
████ owls are ███████████████████████
████████████████ for good luck ██ a future-oriented,
collectively witnessed ritual ████████ grandiose terminology █████
████████. Apparently, ███████████████████████████████
ideal for public sculpture; ██ clear is how it functions as part of a
████████ ephemeral sculpture. The stripes ███████████████
███
are, ███████████████████████████ Op art and popular design.
████████████ pointing to the existence of such styles should be of
particular critical value ████████████████████
████████ the painting ███████████████████ offer variety ██
████ *The train takes you where it goes* (all works 2008) depicts a
rough network of gray and white ████████████████ a simplified ████
plan, while the surface of *Pick up the right things* is divided by zones
of gentle color. *Bridges among water*, with its array of spreading con-
tours, continues the geographical-topographical theme ████████████
████ ████ *We live in the third world from the sun. Number three.
Nobody tells us what to do* expands the scale ████████ to present
what looks like the outline of a whole ████████. *It's always time to leave*
and *The wind blows your hat off* look more thoroughly abstract; both
feature dark shapes edging away from the compositions' centers.

It's all ██
████████████████████████ critiquing what defines the
various genres she alludes to, using familiar signifiers to ensure we are
aware of this intention. Just as clearly, she admires the retinal-cerebral
buzz generated by effective abstraction. ████████████████████
████████ she is an engaging thinker about the slippery intersection
of art and its various sites and publics. ███ in order for any of these
████████ to benefit from the full weight of her intellectual commit-
ment and technical skills, ████████—as ████ the viewer—████████
████████████ move!

I'm almost never in physical proximity to assholes during the day—a decided benefit of professional blogging. But assholery finds a way, even online, and by far the most aggravating part of my job comes in the form of various breaches in netiquette. The following essay surveys online communication at its worst.

The Prank
Like most people, I've got better things to do with my time than prank my friends (or even my hate-reads), but that hasn't thwarted the development of Goatse culture. This trick, which not surprisingly is more popular among men than women, involves a disguised link leading to an image of a man spreading his dilated anus to expose his rectum. It should go without saying that sending someone this image is unacceptable, even as hate mail.

The Email
Don't ask your friends for Goatse sympathy if you commit the following email gaffes: forwarding unlabeled not-safe-for-work emails; sending endless, stream-of-consciousness messages; willfully disregarding the blind cc field; and forwarding private email exchanges. We all break this last rule from time to time, but we shouldn't. The last thing anyone wants to see is their email published on someone else's blog.

The Chat
Speaking of privacy, the ability to IM people on Facebook and Gmail is not an invitation to do so. I often sign in to Facebook chat to say hello to friends from high school—I'm not there to discuss press releases. By the same token, while contacting a long-lost friend via IM is fine, having something to say doesn't hurt, either. Look at their Facebook information page before asking them what they're up to. At the bare minimum, chatting requires the appearance of giving a shit.

The Facebook
Respect for other people's time, space, and privacy goes a long way. On Facebook, uploading a cock shot and tagging your friend in the picture might get their account deleted, as well as your own, so don't let that joke run too long. Don't litter your friend's wall with links to your own work, don't leave inane comments on other people's pages, and don't spam them with endless drinking, flower, and luck invitation requests. In short, be respectful of other people's space.

The Break Up

I haven't always been a stellar role model in this regard, but try to remember your web manners during a break up. My most egregious breach of netiquette occurred when, in the heat of battle, I subscribed an abusive ex-boyfriend's primary email account to every spammer I could find. I assumed that subscribing him to a newsletter espousing the virtues of free-market economies was what gave me away, but in actuality it was something much simpler—I hadn't bothered to ensure that my IP address couldn't be traced. The lesson to be learned here is twofold. First, no matter how much you hate them, don't subscribe people to spam. Having to change a personal or professional email address creates all kinds of problems no one should have to go through. This revenge tactic goes far beyond any appropriate expression of anger. However, if there's nothing that can be said to dissuade you from the Internet equivalent of throwing your boyfriend's clothes out the window, at least do it from the Apple iStore. It's a good way to cover your tracks, and, at the very least, they're likely to have a class you can attend on the subject while combing the Web for receptive spammers.

DUSHKO PETROVICH

What are the rules of etiquette for the art world?

Artists have been rule breakers for a while now, and then, more recently, we were *allowed* to be rule breakers. This meant we could, in theory, wear rumpled pants to a wedding, use curse words, or forget to show up for a meeting. "That's OK—he's an artist!"

Then of course, we were *expected* to be rule breakers, to lead the charge against outdated social formalities—monogamy, grooming, handshakes, and the rest. That went pretty well.

So well that there is precious territory left to conquer. Nowadays, bad manners can seem gratuitous, or even counter-revolutionary. With so many people practicing rudeness, it's hard to tell who the real innovators are.

Connoisseurs will gravitate to those who are repeating past transgressions—with subtle variations—in traditional venues. However, I am more impressed with the creative forces at work on the internet, where new social spaces allow for bold new breaches of etiquette.

Was etiquette foregrounded in any memorable situation?

I am always forgetting peoples' names. At a party one time, I couldn't remember this guy's name. He noticed, and protected our mutual pride by accusing me of being "shitfaced." I was sober enough to go along with it.

What customs or mannerisms are particular to the art world?

People aren't famous for their looks, so you don't necessarily know what famous people look like. One time I was at a dinner and an older woman approached me, shook my hand warmly, and congratulated me on a catalogue essay I had written. She said, "I have always thought artists—if they could write at all—were the best writers on art." I nodded appreciatively, chewed my food, and mumbled some phrase of agreement. When the person next to me greeted her as Dore, I sensed my mistake.

When does breach of etiquette play a role in embarrassing or awkward encounters?

One time, I dated an artist friend's sister, and then broke up with her.

Later, he was very rude to me, and nice, and then rude again.

I could never tell if it was the dating or the breaking up that brought it on.

Has there been a shift in etiquette as the financial climate has changed?

People have started citing the economy as an excuse for their behavior.

What constitutes bad manners?

Putting yourself above others.

SARA GREENBERGER RAFFERTY

What are the rules of etiquette for the art world?

He who smelt it, dealt it.

He who denied it, supplied it.

He who deduced it, produced it.

He who attributed it, distributed it.

He who detected it, projected it.

He who perceived it, conceived it.

He who expressed it, compressed it.

He who related it, deflated it.

He who protested it, foam-crested it.

He who derided it, provided it.

He who maligned it, designed it.

He who smelled it, expelled it.

He who opined it, refined it.

He who rued it, brewed it.

He who revealed it, peeled it.

He who quipped it, ripped it.

He who knew it, blew it.

He who reported it, exported it.

He who decoyed it, deployed it.

He who averred it, disinterred it.

He who eschewed it, spewed it.

He who mocked it, knocked it.

He who tells of it, smells of it.

He who spoke it, broke it.

He who disclaimed it, enflamed it.

He who exposed it, composed it.

He who noted it, floated it.

He who relayed it, sprayed it.

He who damned it, grand-slammed it.

He who said it, shed it.

He who relayed it, made it.

He who thought it, wrought it.

He who unearthed it, birthed it.

He who sensed it, dispensed it.

He who sensed it, commenced it.

He who disputed it, tooted it.

He who squeaked it, cheeked it.

He who berated it, created it.

He who spurned it, burned it.

He who declared it, aired it.

He who blurted it, squirted it.

He who speaks it, reeks it.

He who committed it, emitted it.

He who shunned it, tail-gunned it.

He who rebuked it, nuked it.

He who hyped it, piped it.

He who blamed it, flamed it.

(Source: http://werbach.com/stuff/smelt.html.
Accessed: April 4, 2009. Last updated: April 18, 2004.)

Was etiquette foregrounded in any memorable situation?

If by etiquette, you mean nervous energy: yes. My awkwardness and insecurity blended with the other person's insecurity and awkwardness.

What customs or mannerisms are particular to the art world?

I've never worked in any other world, except retail.

When does breach of etiquette play a role in embarrassing or awkward encounters?

Trick question?

How should people behave? What would be a maxim for appropriate conduct?

People should follow that rule about treating others as they'd like to be treated. I'm also a fan of honesty, even when it is not flattering. But being honest is not the norm in art world etiquette. Also, as a maxim, I like to give at least as much as I get.

Has there been a shift in etiquette as the financial climate has changed?

We all have less to give.

What constitutes bad manners?

Who farted?

What are the rules of etiquette for the art world?

My observation is that etiquette is wildly diverse, thus requiring great elasticity by those who occupy the lower social, professional, and economic ranks within the contemporary art apparatus. It seems that each figure of authority culls his or her own style of etiquette, decorum, and behavioral expectations. Watching artists assess and adapt to these different situations on the fly is staggering. Art fairs are a great place to observe such adaptive behavior.

Was etiquette foregrounded in any memorable situation?

European royalty and heads of state were in attendance at the grand opening of MUDAM in Luxembourg, and the artists participating in the exhibitions were briefed in proper rules of etiquette and protocol. My guess is that the foregrounding of etiquette is a common occurrence when state, diplomatic and culture institutions come together in ceremony.

What customs or mannerisms are particular to the art world?

Manners and customs are highly individualistic and as diverse as art-world couture, but this multiplicity of social behavior underscores distinction and status, not equality.

When does breach of etiquette play a role in embarrassing or awkward encounters?

The Fondation Cartier in Cahors, France, was throwing an afternoon lunch celebrating the exhibition "La Sphère de l'Intime," curated by Jerome Sans. Sans greeted fellow curator and friend Peter Doroshenko with, "you wear a T-shirt to my party?" Doroshenko replied that it was from agnès b. Sans was being playful, but there was also a cutting whiff of offense in his comment. Those of us in earshot immediately fell into rank and file, mentally preparing a defense for our shirts and blouses.

How should people behave? What would be a maxim for appropriate conduct?

Kindly and with regard.

Has there been a shift in etiquette as the financial climate has changed?

People are behaving more vulnerably, but I haven't observed a renewed interest in the ideals of etiquette. Etiquette is selfless. In a downturn economy people are inevitably self-interested.

What constitutes bad manners?

The worst offense is not getting back to others who professionally (or even sincerely) request something of you. Not responding does not mean "no." Have the courtesy to simply respond with an answer.

So firstly, how, or more importantly why, should the rules of etiquette in the art world differ from those in the "real" world? The situations it provides don't appear formally that different from situations in the real world, that would be dealt with in any guide to etiquette. The easiest solution would be simply to refer to your Debrett's and substitute the words "Private View" for "Dinner Party," "Gallerist "for "Host," "Emerging Artist" for "Casual Acquaintance," etc., etc. So the need for such a guide seems to be the main concern. Is it naive to think that all people should be treated with an equal amount of respect and courtesy? Surely the need for new rules specific to the art world stems from more negative reasons than positive. Private views are a situation where supposed friends can become suddenly quiet and quite distrait when someone more "important" or influential enters the room; commercial galleries rely heavily on intern labor and yet are loath to grant their interns many of the basic human rights available to anybody working in almost any other industry. The reasoning seems to be that you should feel lucky to be there, so you better put up with the unreasonable demands and technically illegal working conditions because there'll be a hundred prospective interns waiting to take your place. Not to mention the lack of respect, to bring us back to the initial question. Any demand then, for a separate guide to etiquette for the art world, seems to stem from the need for an out, a carte blanche, a dispensation from the usual rules of etiquette.

The distance between standard etiquette and art-world etiquette seems analogous to the distance between art and the art world. Rather than a generous, constructive philosophy, the hyper-inflated market turns the art world into an exclusive, introspective, onanistic world of in-jokes and self-reference out for its own self-preservation. Only the hyper-inflated egos at various levels of the hierarchy thus created demand a separate etiquette, to allow them to opt out of the inconvenience of having to treat everybody equally. Does this make me some kind of communist?

—

I think an arrangement should be made between private-view attendees and organizers. Organizers should not charge for drinks—though we may allow them to put out a contributions box—if attendees agree to not go solely to get drunk, and get silly. In a way this is connected to the attempt to reunite art world and real-world etiquette. If you were hosting a party, you wouldn't charge your guests for drinks, and my main bugbear here is that it's never the poorest artists and students that have a pay-bar—somehow they manage to be hospitable, and are happy for you to see the work.

ETHAN GREENBAUM

What are the rules of etiquette for the art world?

You can't act like you want anything too bad. (It's the unspoken bohemian/aristocratic template that says you either already have everything you need or don't need anything.)

How should people behave? What would be a maxim for appropriate conduct?

Humanely. This means not trafficking in the alienation of others or the obfuscation of artistic intent as methods for appearing "sophisticated."

Has there been a shift in etiquette as the financial climate has changed?

Artists are hosting the parties a lot more now, both literally and metaphorically, and thus the etiquette is geared less towards pleasing people (collectors, dealers, etc.) who support the arts financially.

What are the rules of etiquette for the art world?

Admire artists that haven't "made" it yet; tell people you liked their old work better before anybody else says it; at an opening, glare at people your own age who have a higher status than you; aim to get a bottle, not a highball, as you cruise fellow highball-holders; pretend you don't know the curator you're sitting next to at dinner but talk about another show with the same group of artists somewhere else; go home and rue spending your night out.

What customs or mannerisms are particular to the art world?

Why haven't you helped me yet, when you didn't know I needed help?

When does breach of etiquette play a role in embarrassing or awkward encounters?

Watching the daughter of a New York collector call her mother a "fat whore" and put out her Virginia Slims 100 on a Mondrian drawing in front of her stepfather; hearing an SFMOMA trustee tell an Asian waitress at a reception that he always dreamt of having an orgy with "more than two or three oriental girls"; being told by a Soho gallerist on a coke-fueled tirade that I was "dead in this town."

How should people behave? What would be a maxim for appropriate conduct?

Act with aphasic disregard for experiences within the context of art.

Has there been a shift in etiquette as the financial climate has changed?

It's increasingly hard to disguise the wolf at the door.

What constitutes bad manners?

I no longer know what constitutes good manners these days.

Fuck. Are you serious? It closed? Already? Christ, I could swear it had just opened. Didn't it? I mean, how long was that show up for? Damn it. It seems I'll never do what I want to these days. Because I really did want to see it. And four weeks—including being open on Saturdays—is a long time. I wonder what I should say next time I come across.... I could just say, "I heard your show was great" and then apologize with some backhanded compliment about how I'm so busy these days. Or I could just say nothing and then I won't have said anything that could be used against me. Or I could say I went but didn't sign my name in the register. I mean who fucking can't spare an hour over the course of a month? And I really do like their work.

—

No you're right. You are. It does matter. It totally does. It's not that, it's just—I'm so distracted lately. I haven't been getting any sleep and I can't help but wonder if my Ambien isn't starting to affect my attention span. While just the other day I saw these beautiful watercolors, you know the ones by—uh, shit—what's his name, you know, the ones with the mistakes that are supposed to look intentional but obviously are not and they're hoping someone will buy it thinking how what is really a flaw is actually something very interesting. What's his name? Fuck. I can't remember. Well, anyway, all that afternoon I was telling people how much I liked them. These kind of shitty watercolors. But then the next day when someone else was describing seeing the exact same show I couldn't remember that I'd even seen the show. I mean, I just thought they were talking about someone else and I had totally forgotten that I had really liked the same thing just the day before. So I go and enter the name into my phone looking forward to seeing this show they were describing. But then when I went to the show and realized I'd already seen the show, all the sudden I couldn't stand the work.

—

Another Friday evening, just after work. My "sexy" outfit now seems grotesque after gaining a winters' worth of weight. And I'm dying to stay home instead of going to openings that I feel I somehow should go to. When all I want to do is open a bottle and watch DVDs. Because I might see people I know and I don't want to. But then I might possibly—could imagine—that I could be introduced to someone who's curating a show and then they'll give me their card and then I'll email them and casually mention I'm working on something that might possibly sort of make some sense and then they'll email me back and come over and then it'll start this snowball of exhibitions that I'll never look back from and I'll always remember it's because even though I wanted to stay home tonight I didn't.

RICHARD RYAN

What are the rules of etiquette for the art world?

always go unseen.

Was etiquette foregrounded in any memorable situation?

yes, but I wasn't there.

What customs or mannerisms are particular to the art world?

what art world?

When does breach of etiquette play a role in embarrassing or awkward encounters?

I saw someone who owns a gallery.

Has there been a shift in etiquette as the financial climate has changed?

yes, money is invisible.

What constitutes bad manners?

speaking so that you can be heard.

JAMES BAE (p.52) is a critic from Los Angeles.

JAY BATLLE (p.10) is an artist who lives and works in New York and France. This summer, he will present "Cutting Out the Middleman" at Nyehaus in New York.

ANDREW BERARDINI (p.22) writes fiction and art criticism for Frieze, Art Review, and Rolling Stone.

DIKE BLAIR (p.5) is an artist who lives in New York.

MATTHEW BRANNON (p.53) is an artist who lives in New York. His exhibition, "Iguana," can currently be seen at the Approach gallery in London.

SARI CAREL (p.21) is an artist currently in exile from Brooklyn.

NAOMI FRY (p.30) writes about teenagers, and art.

MARIA ELENA GONZÁLEZ (p.41) is a sculptor who works in Brooklyn and Basel.

MICHELLE GRABNER (p.49) is an artist, writer, and editor. She is also the founder and director of the Suburban, an artist-run project space in Oak Park, Illinois.

ETHAN GREENBAUM (p.51) is a Brooklyn-based artist.

SARA GREENBERGER RAFFERTY (p.47) lives and works in Brooklyn.

A.S. HAMRAH (p.28) is the film critic for n+1.

STEFFANI JEMISON (p.19) will be a fellow in the Core Program in Houston starting in the fall.

PADDY JOHNSON (p.44) is Art Fag City.

ANGIE KEEFER (p.12) lives in Brooklyn.

PREM KRISHNAMURTHY (p.35) is a principal of Project Projects.

DAVID LEVINE (p.37) lives and works in New York and Berlin. His most recent project, "HOPEFUL," is on view at Galerie Feinkost in Berlin.

PAM LINS (p.43) is a sculptor who lives in Brooklyn.

JASON MURISON (p.27) is a curator and writer who lives in New York.

DAN NADEL (p.29), a writer and curator, is also the proprietor of PictureBox Inc.

BOB NICKAS (p.33), a critic and curator based in New York, is always on time for studio visits.

WENDY OLSOFF (p.3) is the cofounder of P·P·O·W Gallery.

DUSHKO PETROVICH (p.46) is a painter who lives in Cambridge, Massachusetts.

KASPAR PINCIS (p.50) is an artist who lives in London. He would like to thank the Carrot Workers' Collective for helping with his contribution.

RICHARD RYAN (p.54) is a painter who lives in western Massachusetts.

JESSICA SLAVEN (p.18) is a Manhattan-based artist and writer.

RYAN STEADMAN (p.4) has recently shown his work at Envoy Enterprises. He lives in New York.

AMANDA TRAGER (p.40) is working on a new video installation with Erik Moskowitz.

RACHEL UFFNER (p.39) is the owner of Rachel Uffner Gallery in New York's Lower East Side.

ROGER WHITE (p.42) is a painter who lives and works in Brooklyn.